A Giant With Blue Windows

A Giant With Blue Windows

Nadia Perrotta

A Giant With Blue Windows

Copyright © 2014 by Nadia Perrotta

All rights reserved. This book or any portion thereof may not be reproduced or used in any manner whatsoever without the express written permission of the publisher except for the use of brief quotations in a book review or scholarly journal.

First Printing: 2014

ISBN: 978-1-326-08320-5

www.nadiaperrotta.com

Ordering Information:
Special discounts are available on quantity purchases by corporations, associations, educators, and others. For details, contact the publisher at the above listed address.

To Vittoria Onorato
the artist who has inspired me
throughout my whole life

I will feel fully satisfied only when I will have awakened curiosity and spurred many to a collective dialogue. The biggest hope is, in fact, what in the footsteps of my modest contribution to Fuscaldo, others can pursue within the research goals always higher ...

Antonio Pupo (Fuscaldese, Writer and Historian)

Preface

There is a current bivalent theme in my works, which is the intrusion of man in nature and the power residing in nature itself. I'm still questioning where the limits of our intrusion should end.
By contesting the division between the realm of memory and the realm of experience, I investigate the dynamics of landscape, including the manipulation of its effects and the limits of spectacle based on our assumptions of what landscape means to us.

Recently I started researching about the versatility of natural forces, taking inspiration from controversial scientific theories like the water memory data collection by Dr. Jacques Beneviste. According to Beneviste water has the property to collect and preserve data. His theory, although very controversial and sometimes mocked by other scientists has found interest in more recent studies and researches.

As artist I am inspired by the powerful metaphor of a possible universal memory retained and preserved by the waters. If this is true, people and communities living by waters may be guardians and mediators unaware of the universal knowledge they retain.

However, because of the socio-political, economic, as well as climate changes, in most

cases, especially in the western world, many of these communities have lost their original connection with the waters. Bound and blinded by a system of things, by a spectacle, created by man against man himself, they turned their backs to the element that gave life to them for centuries. This disconnection has as consequence a loss of their roots and their identity.

The question behind my project is how to preserve the memory of these peoples, how to help these communities to acknowledge the undeniable link they have with the waters.

I then started a journey where I would like to meet communities whose history is strictly connected with waters.
My first project was a residency in Fuscaldo (my home town) a village near the Tirreno Sea in south of Italy, where a community of fishermen is facing the tragic reality of toxic waste being damped into their water, causing damage not only to the local economy but also having serious consequences on their health. Where Sea like a joker plays the double role of life and death. The documentation materials I collected through my interaction with local community has inspired me to write a piece of narrative that is part of the production of a short film, a hybrid across fiction and documentary.

This book is the documentation of my first journey across the memories of watermen.

 Nadia Perrotta

19/09/2014

We've just arrived I've parked the car under the pine trees. The night is really dark, there is a strong smell of good things.

Sea

Trees

Sand

The noise of the sea is so strong. It pierces into my brain and echoes throughout my head. The crickets are so loud! And the train on the Tirrenia railway ... many times companion of numerous sleepless nights in my forgotten past.

My heart beats very fast, pumping like mad. I can't breath deeply.

claustrophobic feeling

20/08/2014

I got up at dawn.

I heard the waters calling me.

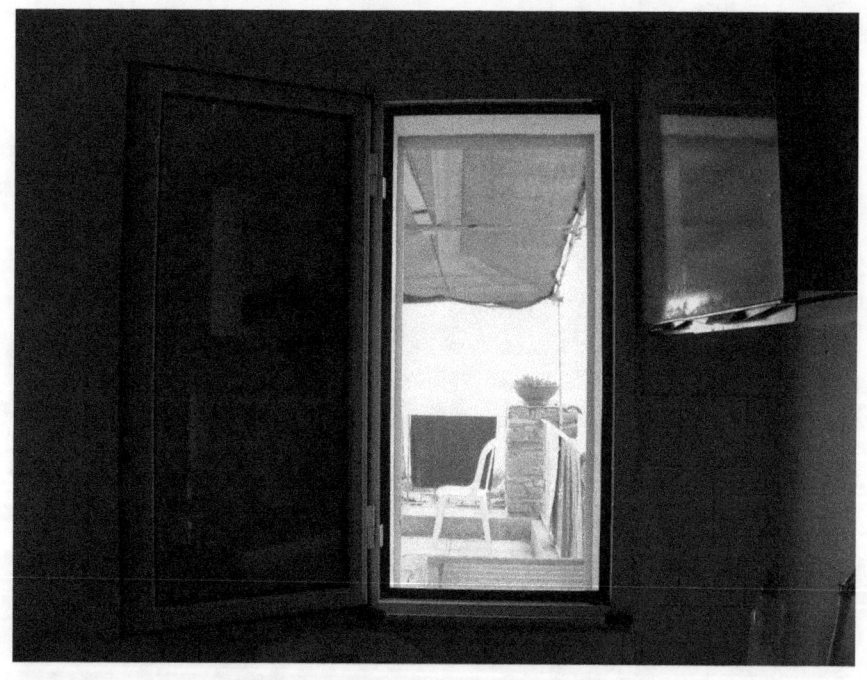

I went walking on the shore

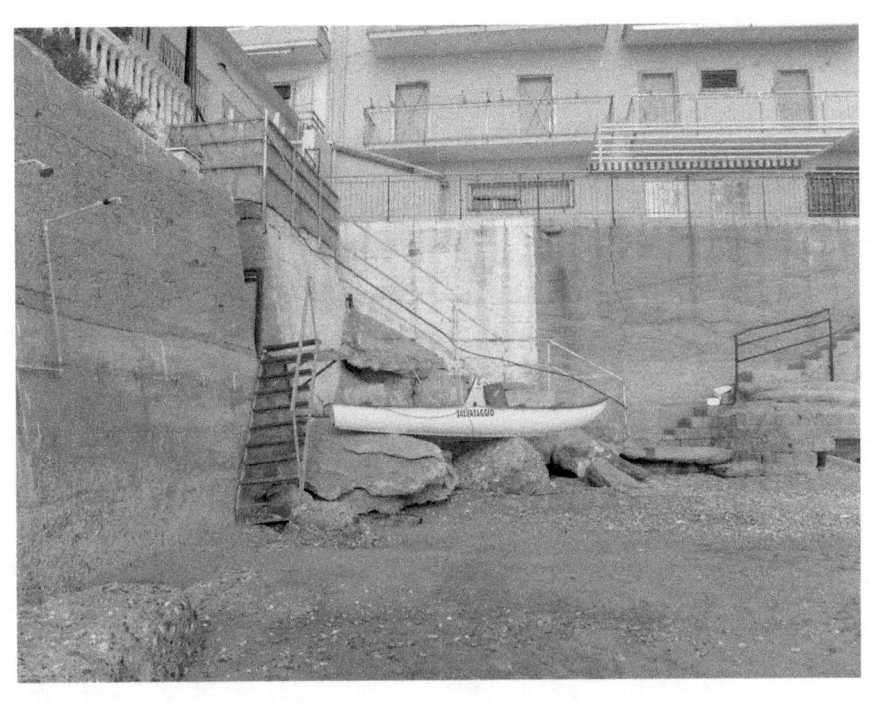

21/09/2014

in the town

everything stands still nothing has changed

houses and buildings

s i m u l a c r a of e m p t i n e s s

in this limbo

across time

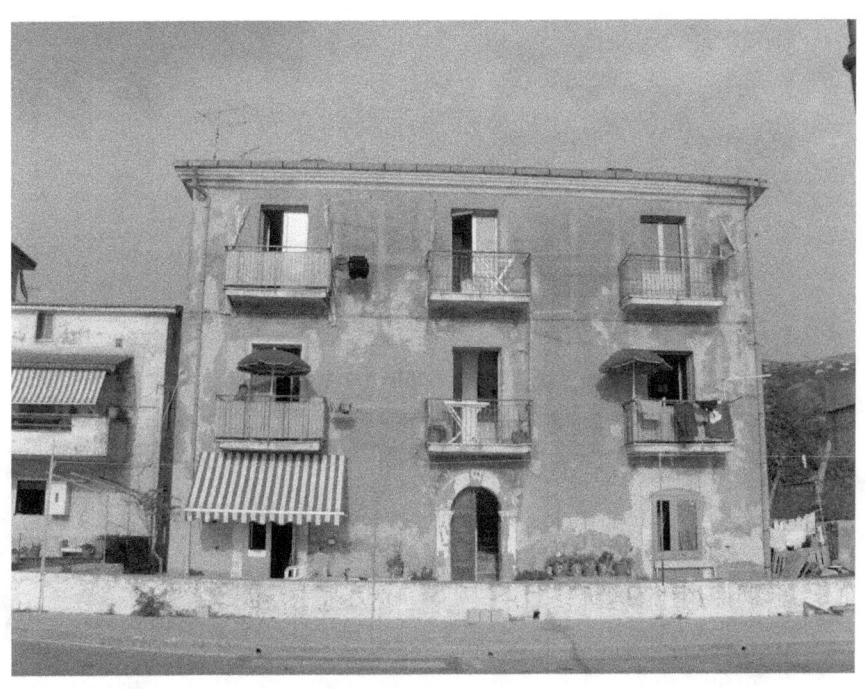

A house near the beach

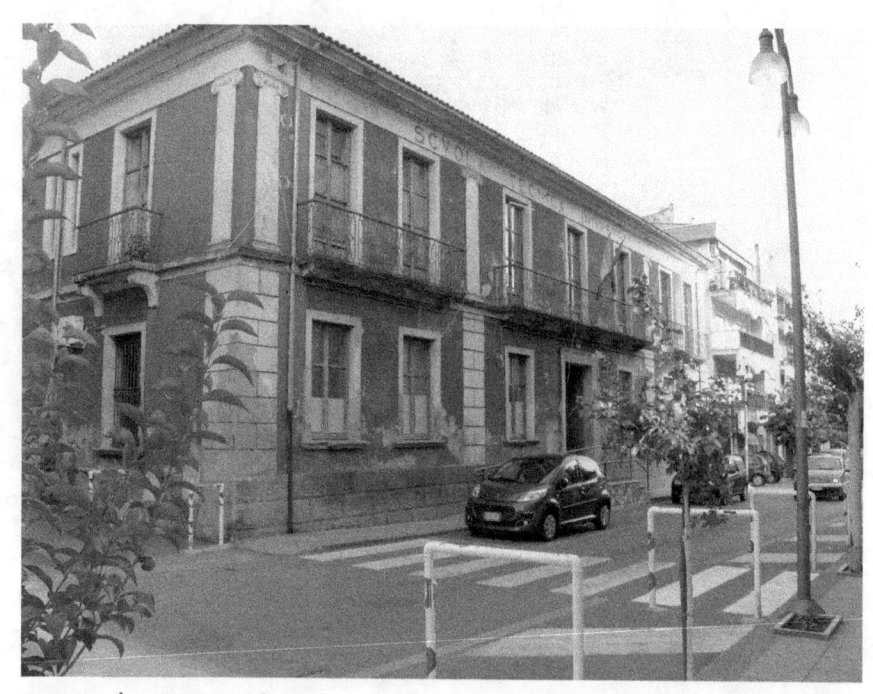

my primary school

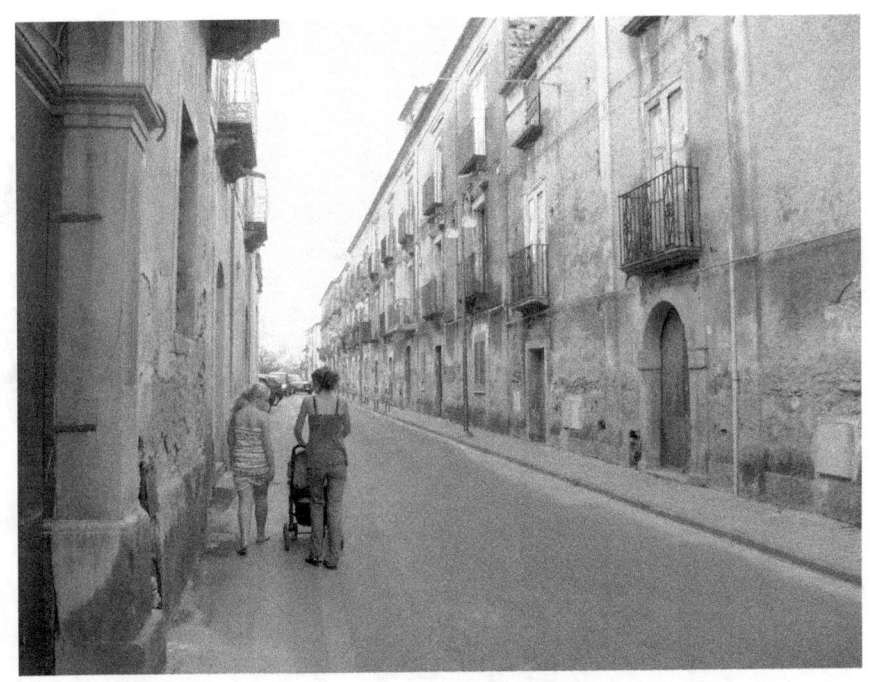
a street

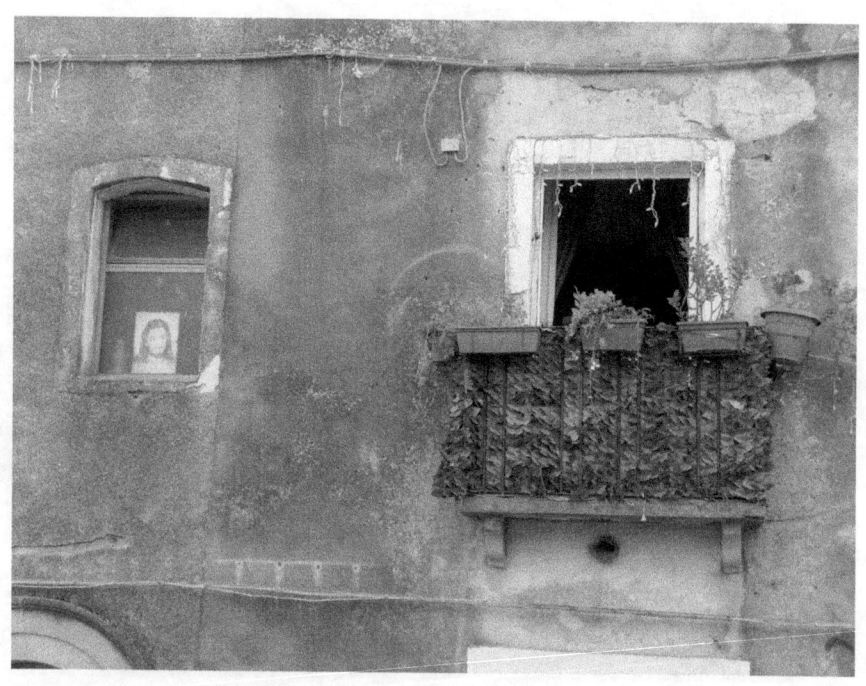

Jesus and plants

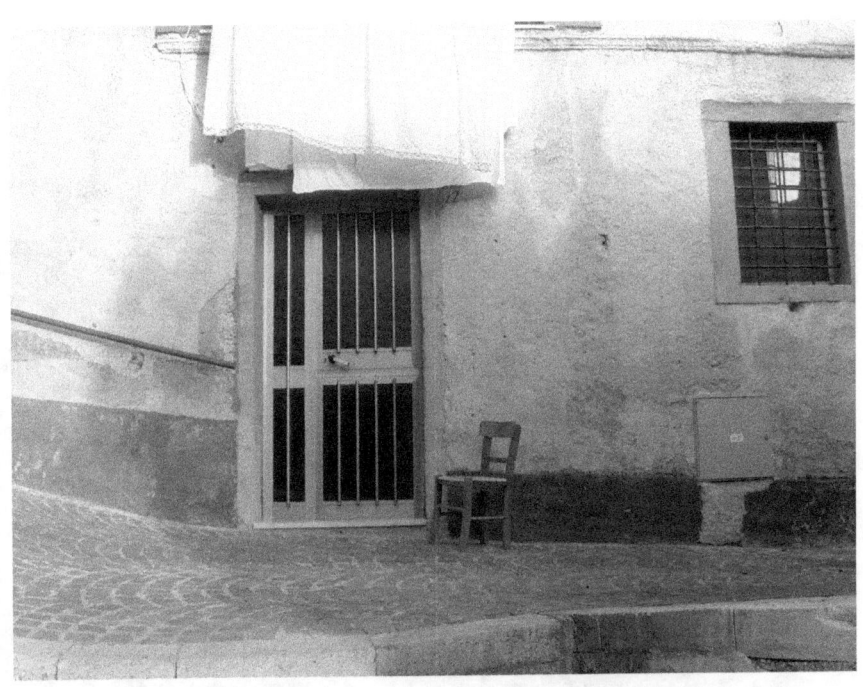
a lonely chair

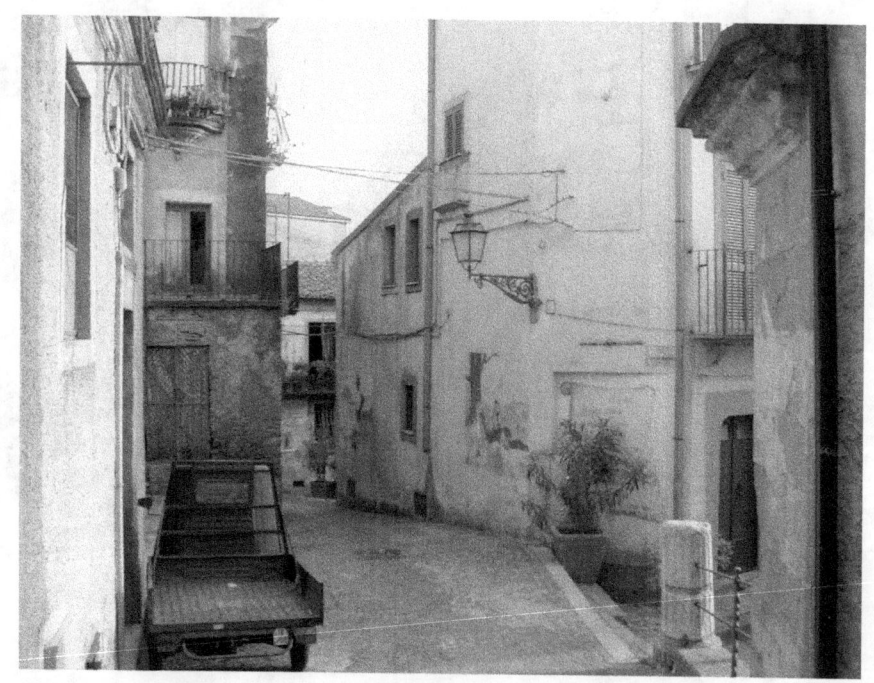

L'Ape Piaggio

Pino is almost vegetarian by now.
He's afraid to eat our fish.

Of my generation all are gone and of his
all are falling ...

one by one.

22/09/2014

A Giant with Blue Windows

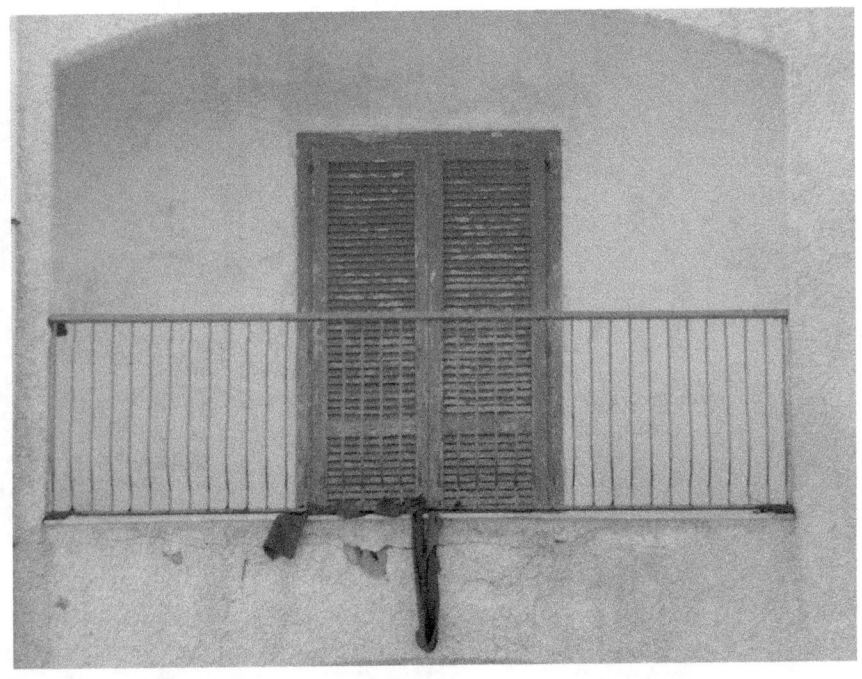

They were many. They came numerous to shut the Giant down. He was sentenced to a slow and irreversible death and the town and everything else around it just followed along.

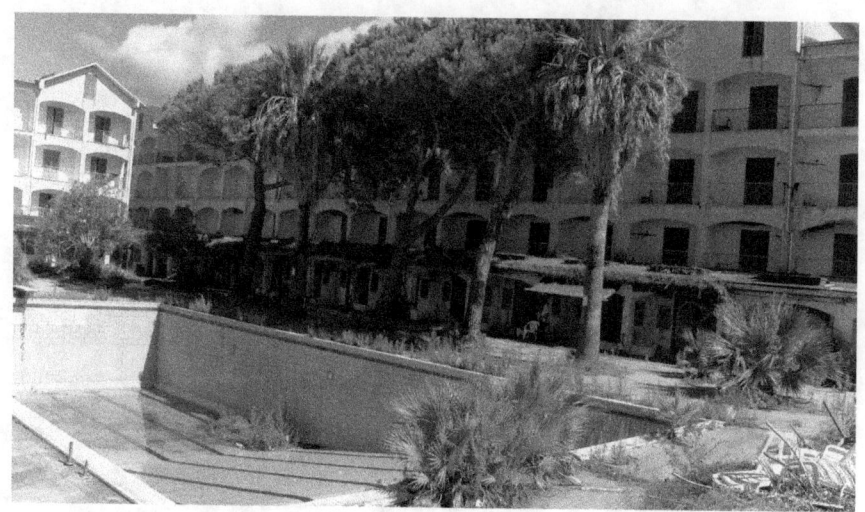

We own nothing here

everything fed to the fish

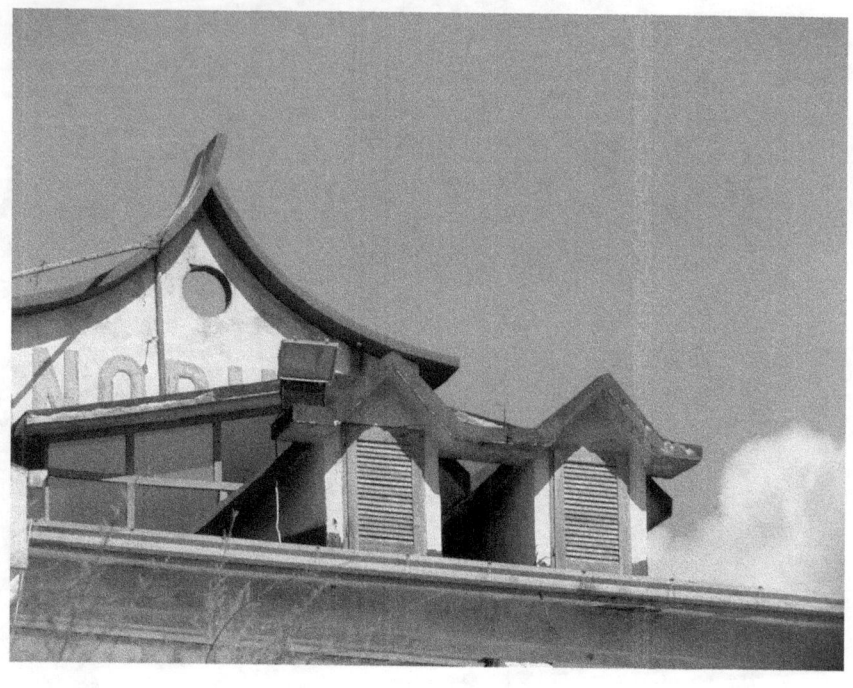

I recognise everything the big pool, the porch, the disco ... the stairs where I, fifteen, used to sneak in, pretending to be foreign among the crowd of tourists ...

Maybe ... they have always known and they have always forgiven me…

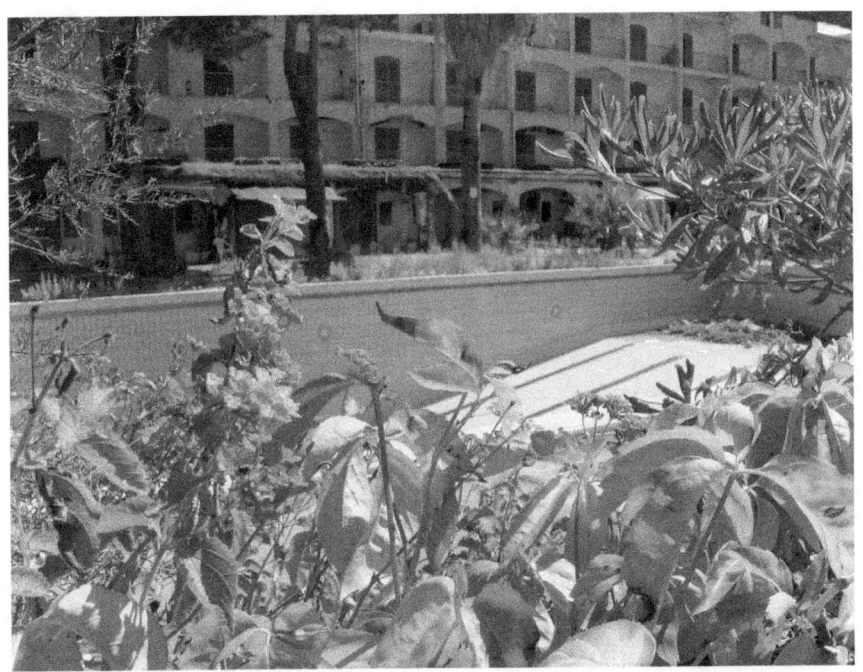

It hurts to see the end of this Big Giant with Blue Windows.

INTERVIEWS

Luigi Spadafora
(my favourite ice-cream maker)

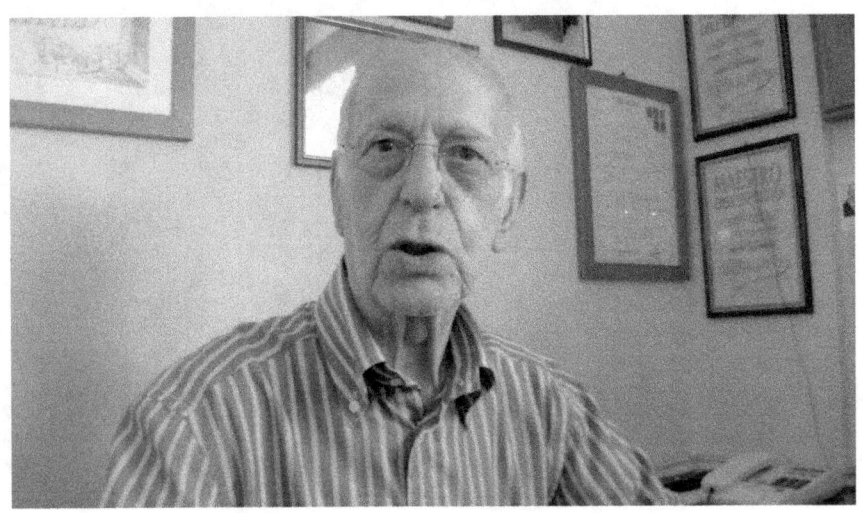

Interview by me
Nadia: what do you think we've lost?
Luigi: We have lost a bit of progress. We are not as before but worse. Practically they are not doing anything to improve this town. Local Authorities do not care about our needs.

Nadia: And what would you save?
Luigi: There is nothing that has been preserved, unfortunately.

Interview by Abi and Ashley
Abi: Did you know my mum when she was little? Was she naughty?
Luigi: No she was a good girl.
Ashley: Did she ate lots of ice cream?
Luigi: Somehow...

The Butcher and His Wife

Nadia: what do you think we've lost?
Butcher: The activity is small and we are loosing because of bigger companies. We have the butcher for forty years and I know that we have to close. Unfortunately, small trades go to die. We need more tourism, because the activity 'is based on tourists not only on the residents. But it's dropped a lot.

Nadia: And what would you save?
Buther's wife: I would like to keep a bit of everything, especially for young people growing up. For them to rediscover the craft, teach them the ancient crafts.

The Old Fisherman

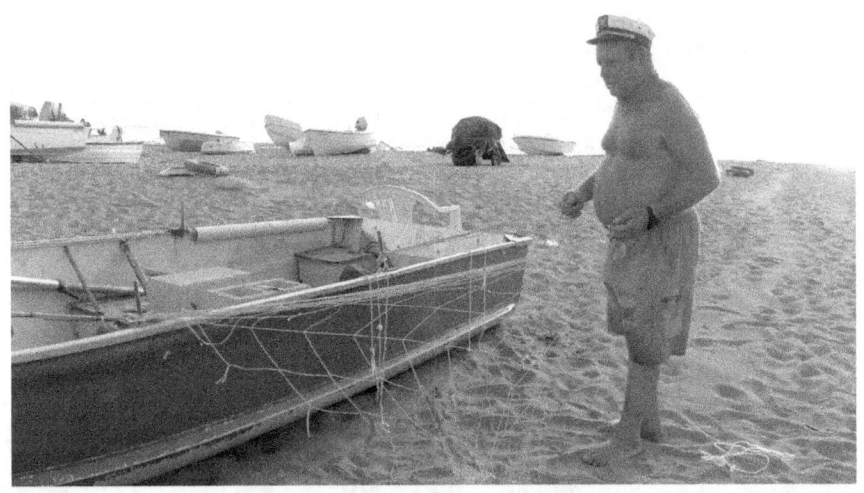

Nadia: I am doing some research for my degree. I am Fuscaldese and I live in England. Before I was at the Marina, here. I lived first in the building of Maselli and then up on the hills. My father was Nino Perrotta, he worked in the admin of the school in Scarcelli. My mother was an artist

Fishermen: Your dad had eye problems...

Nadia: My dad had many health problems. He used to work in schools. He was from Paola but we lived here. I went to school with Francesca Piemontese

Fishermen: She is the daughter of my cousin.

Nadia: I came so many times to do homework here when I was little. I'm doing a research

for my degree and I'm asking to those who live here in Fuscaldo what we have lost and what you would like to keep.

Fishermen: Anyway...

Nadia: Is there anything related to fishing tradition, you would like to keep?

Fishermen: once we fish a lot and now it is all over. That is my wife. Her legs are not so good. I took her to the doctor a few days ago ... now if all goes well ... if not she'll have to go surgery.

Nadia: I'm very sorry to hear that. What were you saying about fisheries?

Fishermen: fish is not enough ... great vessels have ruined everything where they should not come too close... although the captaincy warned them. we cannot fish when they are here, we can be up at eight and then we have to get away... and they take everything.

In the past all the fish caught was a big job. I remember when I was a kid sometimes worked night and day to take them off, one by one from the net. Mister Iannuzzi was our boss. He used to put them in salt. He used to say to my dad *Genna' do not be afraid salt will make them strong!*

Now take those ones with these huge nets … they throw the fish at once inside ice to make them die bursting the heart in their chest inside their own body. All the blood remains in and they are all toxic.
I remember those that we took in summer we used to take them to shore with the belly out, we used to cleaned them thoroughly inside. They had real natural taste.

midnight talks
with my two daughters (Abigail and AShley)
and my two friends and artists
(Jenny Askew and Melissa Jackson)

Jenny Askew

Nadia: Ok go!

Jenny: I thought you were going to ask me something instead of just saying go!

Nadia: (giggles) I just would like to recorder what you told me this afternoon about the experience, your feelings...

Jenny: It has been a very relaxing day ... just sort of been able not to think about any thing ... just been so calm ... it has been good to be able to clear my mind and get rid of pain as well usually walking causes me a lot of pain but because I'm more relaxed it has just become easier.

Nadia: what would you like to keep of today?

Jenny: Just the feeling of complete calm. Just the sort of like a clear mind.

Nadia: What do you think is making you feel that calm?

Jenny: I think being away from the pressure of everyday life. And being in such a clean environment. Being away from the pollution of a big city. It is sort of coming out of my system, as I am feeling better.

Jenny has a chronic condition that limits almost all of her everyday life activities. But her health really improved during our residency.

Abi

Nadia: So Abi what would you like to remember of today?

Abi: Today it was really good I enjoyed every moment from the morning until now what I would probably remember and keep is that an hour ago we were out in the dark in the waves the waves kept on trying pulling us in and taking us out and we kept on screaming

Nadia: what do you think of all the people that we met?

Abi: They know everyone and everything they are very chatty kinda sweet but also weird.

Melissa Jackson

Nadia: What did you enjoy the most? What will you keep of today?

Melissa: Today I enjoyed being around people. I just like being immerse in a completely different culture, seen all the different foods, even the language even though I didn't understand it. I was amazed. I felt completely in a different world.

Nadia: so it was also about the interaction not just the environment but about staying among people.

Melissa: yes because back home it is completely different. You walk down the street and nobody says hello to you and keep their

business to them selves, whereas here is like
everyone is like family...

Ashley

Nadia: What did you enjoy the most today?

Ashley: I enjoyed when we were in the waves because I like the sound of the waves crushing against the shore

Nadia: and you were telling me something about how you feel when you came out of the water...

Ashley: oh yes when I came out the water I still feel the waves going up and down on my back and also when I walk I still feel them

Nadia: is there anything you didn't like today and would like to forget?

Ashley: Yes! When you met your daddy's friend the artist! And he talked a lot and said these jokes that weren't really my age style...

Nadia: you know that we artists we chat a lot.

Ashley: Very! Especially in the galleries!

Nadia: Yes he was talking about his paintings and everything he did. I should have not told him that I am doing fine arts... it is my fault. Sorry.

Nadia: anything else you would like to say?

Ashley: Yes! Go to my mum's favourite ice-cream shop is delish... really I had lemon and pistachio... yum!

EXPERIMENTS

Series of prints using charcoal, sea water,
wild orchids, rocks and sand

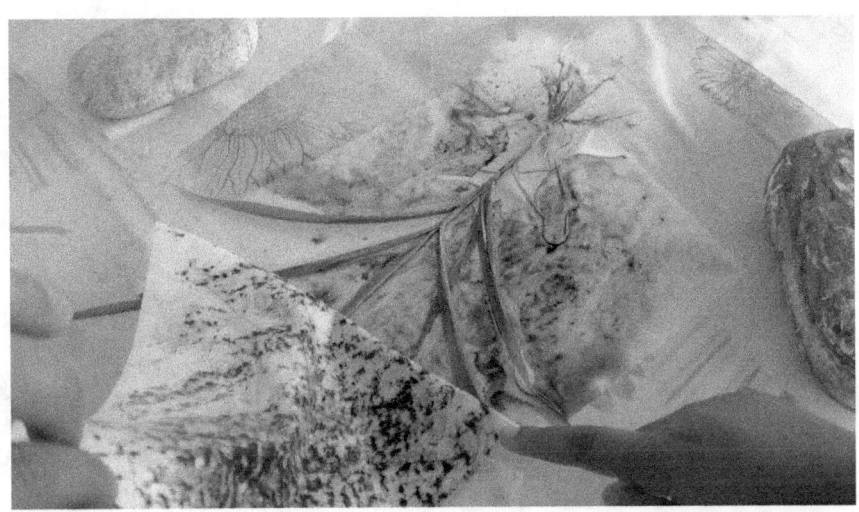

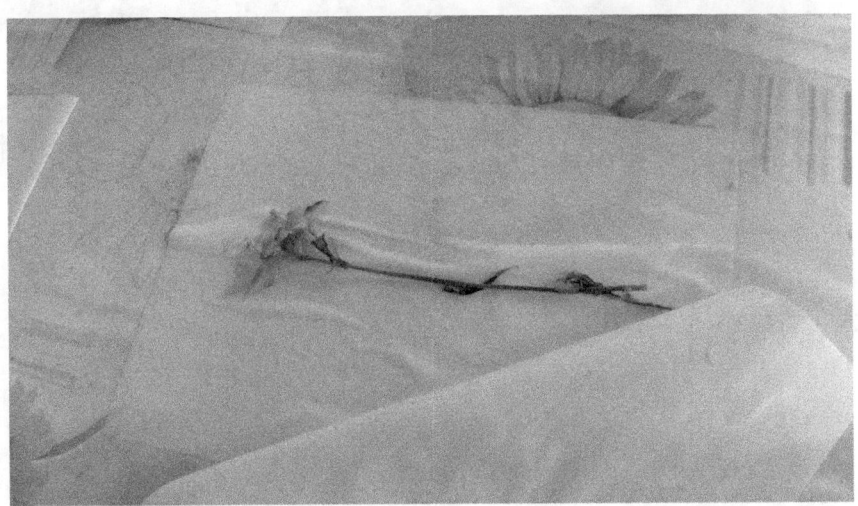

Series of prints using charcoal, sea water, rocks, sand and seaweeds

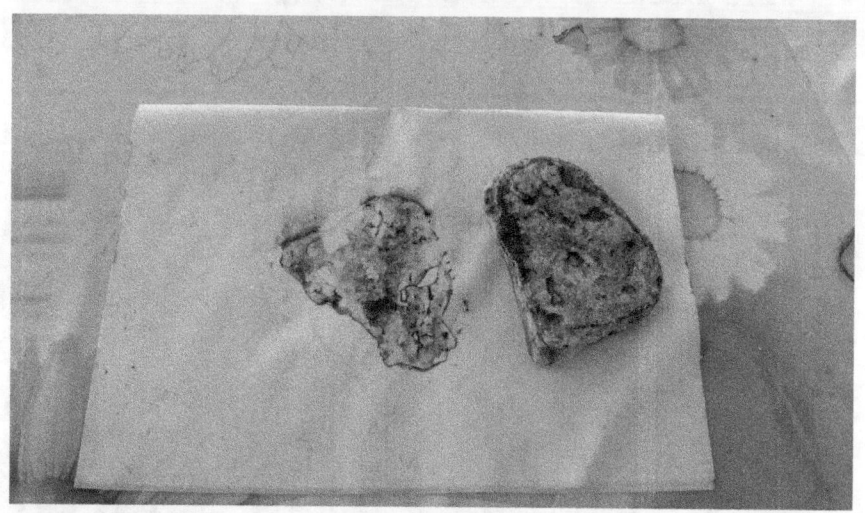

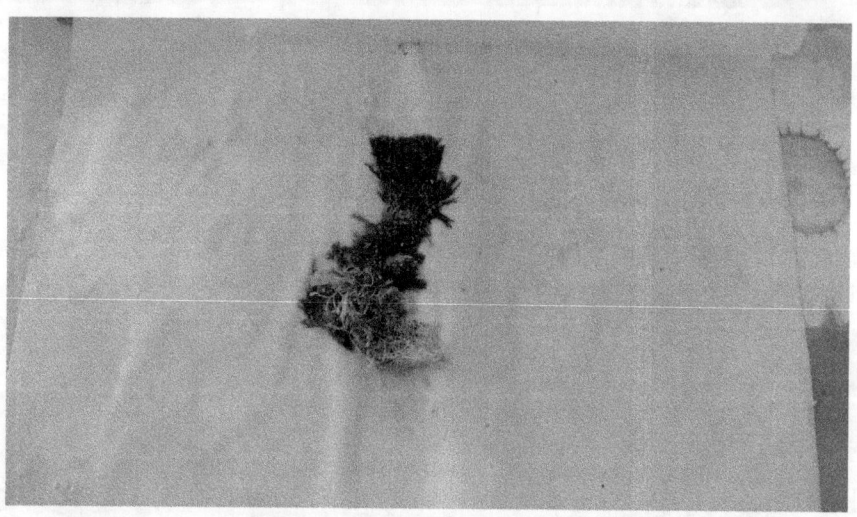

APPENDIX I

Le Navi Dei Veleni

(Poisoned Shipments)

NEWS SCAN

Insights and Analysis about Science and Technology

Energy & Environment

Poisoned Shipments

Are strange, illicit sinkings making the Mediterranean toxic? BY MADHUSREE MUKERJEE

IN OCTOBER 2009 THE GOVERNMENT OF Italy announced that a wreck discovered off the southwestern tip of the country is the *Catania*, a passenger vessel sunk during World War I—and not the *Cunski*, a cargo ship loaded with radioactive waste, as alleged by district authorities from nearby Calabria. Few locals are reassured, says Michael Leonardi of the University of Calabria. He and others maintain that the putative *Cunski* is still out there and is just one of numerous ships full of poisonous garbage that a crime syndicate has scuttled in the Mediterranean Sea. Such a startling allegation, if true, would not only damage the tourism and fishing industries along this idyllic coast but also compromise the health of Mediterranean residents.

Processing and safely storing waste from the chemical, pharmaceutical and other industries can cost hundreds, even thousands, of dollars per ton—which makes illegal disposal highly profitable. According to the Italian environmental organization Legambiente, some waste shippers that have operational bases in southern Italy have been using the Mediterranean as a dump. While acknowledging that "no wreck has yet been found that contains toxic or radioactive waste," physicist Massimo Scalia of the University of Rome, La Sapienza, who has chaired two parliamentary commissions on illegal waste disposal, argues that other evidence makes their existence "beyond reasonable doubt."

Scalia contends that 39 ships were wrecked under questionable circumstances between 1979 and 1995 alone; in every case, he adds, the crew abandoned the ship long before it sank. An average of two ships per year suspiciously disappeared in the Mediterranean during the 1980s and early 1990s, according to Legambiente—and the number has increased to nine wrecks per year since 1995. Paolo Gerbaudo of the Italian daily *il Manifesto*, who is assisting investigations, has identified 74 suspect wrecks of which he regards 20 as being extremely suspicious. (The record extends until 2001.)

One notable example of a dubious wrecking is the *Jolly Rosso*, which washed up in December 1990 near the town of Amantea, after what investigators believe was a botched attempt to scuttle it. The cargo was offloaded and allegedly buried on land. In October 2009 an environmental ministry report noted that district authorities detected dangerous substances in a nearby river valley, including a buried concrete block containing mercury, cobalt, selenium and thallium at very high concentrations—and displaying substantial radioactivity indicative of synthetic radionuclides. Authorities also found marble granules mixed in with thousands of cubic meters of earth, which was contaminated with heavy metals and cesium 137, typically a waste product of nuclear reactors. The assemblage suggests that the *Jolly Rosso*'s cargo included radioactive waste, sealed in concrete and shielded from detection by marble dust (which absorbs radioactivity).

Significantly, the increase in the frequency of wrecking correlates with the progressive tightening of international dumping regulations. The first suspect sinking, in 1979, occurred the year after the Barcelona Convention, which restricts the disposal of pollutants in the Mediterranean Sea, came into force. Over the following decades other treaties expanded the regulations, culminating in a 1993 amendment to the London Dumping Convention that halted the ocean disposal of all radioactive waste and in a 1995 amendment to the Basel Convention that banned the deposition of the industrial world's lethal excreta in developing countries. The

Suspicious Cargo Shipwrecks, 1979–2001

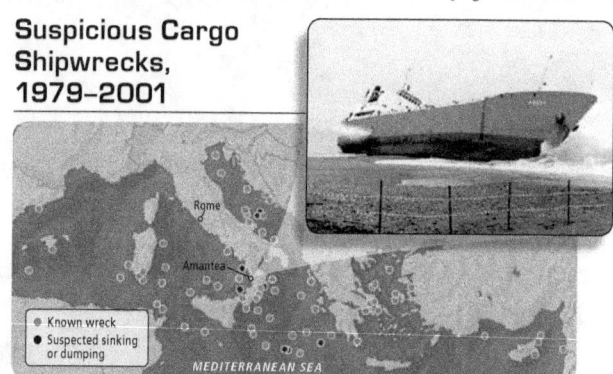

- Known wreck
- Suspected sinking or dumping

SUSPECT SINKINGS have occurred in the Mediterranean. (A wreck is deemed suspicious based on location, timing, registration, ownership history and other factors.) Perhaps the most infamous is the *Jolly Rosso* (*inset*), which ran aground near Amantea, Italy, in December 1990; the bright red hull is the result of a repainting job after stranding, perhaps done to hide markings. The map data include known sinkings and strandings (*red*) and suspected wreck sites or dumping areas (*black*). A more detailed map appears at http://tiny.cc/9aAVg.

laws ruined the ambitious plans of one firm, Oceanic Disposal Management, incorporated in the British Virgin Islands, to drop tens of thousands of cubic meters of radioactive waste into the seabed off the African coast. Andreas Bernstorff, who formerly headed a Greenpeace campaign against the trade in toxic waste, reports that the number of schemes to ship such garbage to Africa fell steeply at this time, to at most one attempt per year. The drop coincides with a sudden and ominous rise in the frequency with which ships in the Mediterranean perished.

Despite profound concern in southern Italy, efforts to find the wrecks and identify their cargo have been slow. The endeavor is expensive, Scalia notes, and requires "serious engagement by magistrates and politicians"—which, but for "a few honorable exceptions," has been lacking. Fear of violence may also have hindered investigation. In 1994 Italian television journalist Ilaria Alpi and cameraman Miran Hrovatin were shot dead near Mogadishu, after they picked up the hazardous waste trail in Somalia, where political upheaval has kept the country from enforcing controls.

That African nation possibly holds clues to the kinds of health hazards Italians might face. "My committee heard from Somalians who said many people in that area had symptoms of poisoning and some died," Scalia attests, referring to a stretch of highway along which Alpi and Hrovatin may have witnessed the offloading of toxic substances. The tsunami of December 2004 dredged up giant metal containers from the seabed and placed them on Somali beaches—proving that the country's coastal waters had also received questionable trash. A United Nations report blamed fumes from these unidentified objects for internal hemorrhages and deaths of local people.

In April 2007 Calabrian authorities had temporarily halted fishing in waters off Cetraro (where the *Cunski* lies, according to a turncoat from the 'Ndrangheta mafia) because of dangerous levels of heavy metals in marine sediment. In the region around Amantea, mortality from cancer between 1992 and 2001 exceeded that in neighboring areas, a study found; just as worrisome, hospitalizations for certain malignancies have risen in recent years.

"Almost all the coastal regions of our country may be compromised," warned 28 Italian legislators from opposition parties on October 1, in a parliamentary motion demanding that the sunken ships be located and their contents secured. Until investigators can salvage the truth about the shipwrecks, suspicion and anxiety will plague the Mediterranean shores.

Madhusree Mukerjee is author of the forthcoming book Churchill's Secret War, *about England's famine-inducing colonial policies during World War II (Basic Books 2010).*

APPENDIX II
17 JULY 1996

17 JULY 1996

the day is hot like many others in this season. the bully sound of splashing water on the rocks enters through the open balcony. the smell of salty air mingles with that of chloroform. it is almost a toxic mixture. it makes me feel dizzy. I watch you while you sleep. you seem almost a child, among your white sheets. your countenance is serene, as if life had given you another chance. I wonder what you're dreaming. maybe some of your friends angels came back to find you. those ones who nightly relieve your pain and at the same time annoy you with their fanfare. if by chance they come back to see you, ask of me what will happen tomorrow. no strength is left in me to ask such a question. ask what will become of me and my sister, once you leave us alone.

the walls of the room from white became the color of the sunset. better that way ... I can look out and save myself the trouble of pretending to be interested in the daily spectacle of a fiery horizon that makes a mockery of us and continues to mark the end of another day.

your lips are still optimistically narrowed, almost smiling, not even this "evil" managed to deprive you of your sweet smile. I am feeding you as you fed me. I washed you as you washed me. I've combed the few hairs you

have left on the head. I massaged you with oils and creams to relieve your aching muscles. I'm watching the clock. I sent them all away. I want to be the one who takes care of you. yet I know that this is not enough. not repay the lack and pain that I gave you.

it is dark. like every night starting your mourning. there is no morphine that can relieve your pain. I cannot stand to watch you wriggle in pain. I go out on the balcony. I sit here. but I can still hear you. is stronger than ever ... even stronger than when I was there with you. I shake my head in my hands, I try to cover my ears. but your moan resides within me. has taken possession of my brain. I cannot control it and slow tears come down, tears that someone in a movie or novel would call bitter. and bitter they are, as gall.

I PRAY. I BEG. "PUT IT TO END! Grant her peace to end her ordeal and start my own!" I keep repeating these words, until a strange feeling of peace comes into me. I do not know if I am asleep or awake. I see a beautiful garden, an oak and a woman sitting playing with the puppies. has a purple blouse and a pair of jeans. short hair. I hear her laugh. I approach. IT IS YOU. young, beautiful, serene and your smile almost shine on his own.

a cool breeze and light makes me shudder. I open my eyes. it is dawn. you do not complain anymore. I run in the room. check if you breath. Yes. you're just sleeping. you feel my presence. open your big brown eyes that now can not see me anymore. I did just in time three days ago to write down in macroscopic letters I LOVE YOU. is the last thing you saw. I smile and I hug you. you raise up your head a little. I take you in my arms. I feel a breath, more intense than usual. and then nothing more. I hold strong. and cry. I'm afraid to let you go on the pillow. I'm afraid to look at your face. the nurse comes and divides us by force. called the doctors. and as I leave the room, for the last time I see your face pale your lips no longer pink, but white as marble.

... and in the meantime the nurse covers you from my view with your fresh, white and clean sheets.

www.ingramcontent.com/pod-product-compliance
Lightning Source LLC
Chambersburg PA
CBHW072248170526
45158CB00003BA/1029